Peerless

Japanese

Transparent

Water=Colors

"The Self Blending Colors"

Peerless
Japanese Transparent Water Colors
PREPARED ONLY BY
JAPANESE WATER-COLOR CO.,
NEW YORK & BOSTON.

NEW YORK.
144 E. 34TH ST.

BOSTON.
600 TREMONT TEMPLE.

AND TOKIO, JAPAN.

For the Artistic Tinting of Photographs, Lantern Slides, Half-Tones, Magazine Prints and Process work of all kinds where a PERFECTLY TRANSPARENT COLOR is required.

These **Peerless Japanese Water-Colors** are for sale by all dealers in Artists' Materials, Photo Supplies, etc., or will be mailed post-paid by addressing as above.

Prices.—Complete Booklet of 16 colors, 75c. School Edition, 4 colors, 25c. Separate leaflets of Transparent Colors, 5c. each.

Copyright 1902 by C. F. Nicholsen.

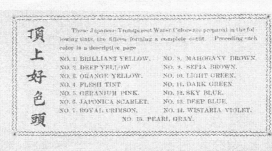

These Japanese Transparent Water Colors are prepared in the following tints, the fifteen forming a complete outfit. Preceding each color is a descriptive page.

NO. 1. BRILLIANT YELLOW.	NO. 8. MAHOGANY BROWN.
NO. 2. DEEP YELLOW.	NO. 9. SEPIA BROWN.
NO. 3. ORANGE YELLOW.	NO. 10. LIGHT GREEN.
NO. 4. FLESH TINT.	NO. 11. DARK GREEN.
NO. 5. GERANIUM PINK.	NO. 12. SKY BLUE.
NO. 6. JAPONICA SCARLET.	NO. 13. DEEP BLUE.
NO. 7. ROYAL CRIMSON.	NO. 14. WISTARIA VIOLET.

NO. 15. PEARL GRAY.

頂上好色頭

THE art of TRANSPARENT TINTING had its origin in Japan and the wonderful skill of the Japanese artists in this line of work has excited universal admiration.

Previous to the introduction of these Japanese Water-Colors, users of transparent colors were confined to bottled inks. These proved very unsatisfactory for obvious reasons. Transparent colors in cakes, porcelains, &c., have always been impracticable on account of the base necessary to sustain the color taking the form of grit and sediment when the color is laid on; the ingenious form in which our colors are offered entirely obviates all trouble of this nature. Their lightness in weight, as compared with the ordinary paint-box, is an important advantage and worth considering.

頂上好色·頭

These colors are concentrated and very strong, so great care must be exercised in not having washes too deep; better go over it lightly two or three times with a weak wash while paper is still wet, rather than try to get the correct shade at first with a deep wash. In landscape tinting finish the skies first; use plenty of water and PUT ON QUICKLY; sponge off any surplus water, or absorb it with blotting paper before it dries, otherwise a blotched or clouded effect will be the result.

Where there are mountains, or hills, carry sky wash, if of Blue, down over them, as this adds much to the distant effect when Green is used in foreground and the middle distance.

When there are clouds in a picture a very light wash must be used. When objects in the picture are printed a natural color, as, for instance, the bark of trees, an old fence, or a weather-beaten building, put no color on whatever. A rich sunset effect is produced by wash-

ing Yellow from horizon to upper sky line, deep at horizon and gradually diminishing as it approaches upper sky line. This is fully explained in another chapter. Where a deep color is required for detail work, use direct from the color leaflet.

Go to Nature for effects; watch a beautiful sunset and try to imitate it with these beautiful Japanese Water Colors.

SPECIAL NOTICE.

These Peerless Japanese Transparent Water Colors are superceeding all other colors for use in PYROGRAPHY and are now very generally used in conjunction with this interesting art; they render it even more facinating.

The use of Japanese Transparent Water-Colors in School Work.

頂上好色頭

The first trial of these colors will tend to convince the up-to-date teacher of the impracticability of using the opaque colors now in general use for CLASS INSTRUCTION, with a view of cultivating the natural artistic talent of the pupil. In public and private schools, and particularly in the kindergarten, not one pupil in fifty will evince natural artistic talent to a marked degree, and in any case much training is always necessary to perfect the pupil in perspective and proportion. To avoid monotony the crude drawings are colored, resulting in the production of work that is anything but satisfactory, and in most cases very discouraging for both teacher and pupil.

With the introduction of our Japanese Transparent Water-Colors a radical change is effected, and while instruction in drawing may proceed as formerly, the pupils' sense of color and artistic ability may be developed in a vastly more effective and entertaining way by the use of our Transparent Colors in connection with copies of the best examples of art. These pictures are made by several different processes,

the price varying with the process. Excellent pictures, well adapted for coloring, can be obtained at from 2½ to 6¼ cents in small lots, and cheaper by the hundred, are issued by art publishers, and offer an unlimited assortment of landscapes, marine views, figure pieces, birds, animals, &c., to choose from. In addition to the foregoing, all illustrated magazines, art publications, &c., offer an abundant supply of pictures that may be utilized for coloring.

Japanese Water-Colors for the Children.

While not designed as a toy, this booklet of Transparent Water-Colors as a gift for children cannot be rivaled for usefulness and will be received with delight by any child, as from no childish pastime is so much pleasure derived as in looking at picture books; and if the pictures be colored, the book becomes a veritable treasure in the child's eye.

Very few children can make a satisfactory drawing, and consequently they have to confine themselves to the coloring of illustrations where both outline and shading are supplied. The colors used are

頂上好色・頭

generally hard and insoluble, and when color is finally obtained by hard and patient rubbing, it proves to be dull and OPAQUE. This color, of course, obscures all lines and shading and it is not wonderful that the paints are soon laid aside in discouragement.

These Japanese Water-Colors are PERFECTLY TRANSPARENT and it is only necessary to select the color desired, and as only the fibre of the paper is colored, the outline and shading is in no way obscured. This makes the tinting of pictures a fascinating pleasure, attended by results that will prove an agreeable surprise. One New York daily paper has a regular department for coloring pictures by children, and offers prizes for the best work. This is the straw that marks the direction of public opinion.

For spirited and effective work, cultivate freedom of action. Once your strength of color is decided on in your color dish, lay it on boldly with a free-wrist movement; cover work in hand quickly, and not by repeatedly touching with a timid hand. Outline in your mind just the effect you wish—if working on an original picture—if a copy, study colors well before starting, and then go at the work BOLDLY. Lack

頂上好色頭

of decision usually ends in failure.

Effective work in water-colors requires speed, therefore the handling of the brush correctly is very essential. Where large surfaces are to be covered with a flat wash, considerable practice will be necessary.

In all washes, skies, water, meadows, &c., the flat camel-hair brush is most serviceable. Two one-inch brushes for Yellow and Blue respectively, two of half-inch size for foreground work and remainder can be selected to suit the individual requirements, but we would recommend the use of GOOD BRUSHES, as it is only with these that satisfactory work can be done.

Brushes should be well filled, but not overloaded, as the clearness of a wash largely depends upon this; apply lightly, but with a quick motion, cover thoroughly first time over as the second application may disturb the surface of a print and thus spoil the picture. A little practice and patience will accomplish wonders in this respect.

Have a soft sponge and a sheet of blotting paper at hand to take up any surplus color.

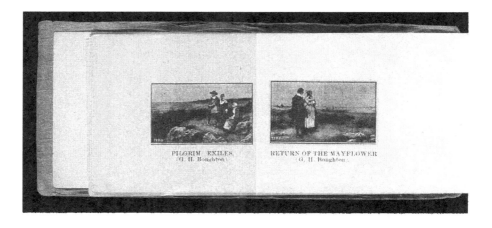

PILGRIM EXILES.
(G. H. Boughton).

RETURN OF THE MAYFLOWER
(G. H. Boughton).

頂上好色頭

A Practical Illustration in the Use of Japanese Transparent Water-Colors.

WE will illustrate the use of these colors by explaining how to color a reproduction of one of Mr. George H. Boughton's notable paintings, "THE PILGRIM EXILES." We have found the publications of the Cosmos Pictures Co., of New York and the Perry Pictures Co., (The United Society of Christian Endeavor, Tremont Temple, Boston, Mass.,) excellent for tinting with these Japanese Transparent Water-Colors. They are printed on a paper the surface of which very nearly imitates the "egg-shell" finish of a fine water-color paper; this reflects the light and produces a very pleasing effect.

An assortment of pictures and color outfits may be purchased at above headquarters in New York and Boston.

TO COLOR—

Invert the picture and commencing at the horizon line wash in sky with a very pale SKY BLUE—using a one-inch flat sable brush, being careful not to wash over the high-light at the meeting of the

頂上好色頭

sky line with water. Next place picture in its natural position, and commencing at the horizon wash down over the water to the shrubs in the foreground with same sky-blue tint, carrying it to line of sand where the surf is rolling in. Then take same sky-blue tint, but of a deeper tint, and wash the sky from the top of the picture about one-third down the sky space, blending into lighter shade where the two meet, so as to show no distinct line of convergence, but a gradual dissolving of one color into the other. Next add a little LIGHT GREEN to blue wash, and color the distant hills showing to the extreme right of picture above the horizon line. These should be of a greenish blue. Now add a little more green and color the distant trees on the point of land extending from water to extreme right of the picture, and back to the figures in foreground. Add a little yellow and color point, commencing at right and extending to the figure of Puritan Maiden. Prepare a light MAHOGANY wash and complete the point to water line. Dilute still more and add a very little PEARL GRAY and color sand in the cove, where the tide has receded. A dilute wash of MAHOGANY, with a little SEPIA BROWN added, will be effective for the

granite rocks in the foreground. Color the grass at the feet of the figure a bright yellowish green, made by adding BRILLIANT YELLOW to LIGHT GREEN. Carry this color over the shrubbery in the foreground, being careful not to color the light leaves on the shrubbery in the left foreground. These leaves can be colored a darker green, or if a rich red-brown is used (made by adding a little JAPONICA SCARLET to MAHOGANY BROWN) the effect is good. The taste and skill of the painter is shown by the way the details are worked out in the foreground, a touch of brown, yellow or green, here and there, adding much to the appearance of the picture. The figures are colored to suit the individual taste of the painter, but quiet, subdued tones will be in keeping with this subject.

Great care must be used in coloring the flesh. Use FLESH TINT of a very weak degree, going over surface several times, or until the desired shade is obtained.

頂上好色頭

※ ※ Japanese Transparent Water-Colors for Photographs. ※ ※

Now that the many kinds of dull finish black and white pictures are so much in vogue, these Colors will immediately appeal to the amateur Photographer. All photographers have many times realized the vast difference between the picture as it appeared on the ground glass and the finished production in cold black and white. The judicious use of a little flesh tint and the coloring of the dress, furniture and surroundings, will result in not only the production of a picture, but a work of art as well. Photographers who make a specialty of landscapes, animals, flowers and still life of all kinds, may, with very little practice, produce work that will rival the best of water-color paintings.

頂上好色頭

✻ ✻ ✻ A Few Hints on Tinting Photographs. ✻ ✻ ✻

We would advise the use of Velox or similar papers when photo is to be tinted, as effects obtained are always satisfactory. Thoroughly wet the unmounted print in clear water, place on sheet of glass or ferrotype board and with a blotter remove surplus water, you are then ready to apply the colors. Put on tints in very weak washes commencing at sky; if a warm yellow or orange sunset is wanted, wash blue from zenith down about two-thirds way to horizon, diminishing strength of blue as you proceed; take yellow brush in hand and carry this col'r to horizon, blending the blue and yellow where they meet, this is easily accomplished as the colors practically blend themselves, then a dash of orange or flash along horizon and one has an effect of perspective that is very striking. The middle distance and foreground can be colored to suit the individual taste, working in the warm greens and browns with a touch of bright yellow and red here and there. If the blotter has been judiciously used a considerable time can be spent in touching up foreground, although we recommend quick work, to be effective. Color a trifle strong in the greens and yellows as they dry fainter, while the blues must be put on in weak washes as they intensify in drying. Remove from glass and place on clean paper to dry. Have a brush for each of the colors, yellow and blue, and do not mistake in picking them up when using; one small size brush will answer for detail work in foreground.

Special leaflet of instructions on the tinting of Lantern-Slides will be sent to purchasers of these Japanese Color Books on receipt of 10 cents. Address all communications to 144 East 14th Street, New York.

* * Japanese Sizing for Solio and other papers that require a * * sizing before tinting with Water-Colors.

Most printing papers will absorb these Japanese Water-Colors at once; a damp sponge, lightly applied, so as not to disturb the surface of the paper, being in most instances all that is necessary before tinting. There are, however, some glossy surfaces that require a special sizing, and our JAPANESE SIZING, in leaflet form, is prepared expressly for these cases.

Mailed with full instructions for use; same price as our Separate Tint Leaflets.

頂上好色頭

* * Japanese Transparent Water-Colors. * *

No. 2.
DEEP YELLOW.

A dark, rich yellow, good for sunset effects. Diluted with water gives naples yellow, cream yellow, old-gold yellow, brass yellow, for touching up old candle sticks, gilt frames, &c. Very useful in foliage work to show direct sunlight effects.

Use direct from leaflet to get a strong, brilliant effect.
Remove clipping after film is dissolved.
Manufactured only by Japanese Water-Color Co., New York, U.S.A.

✻ ✻ Japanese Transparent Water-Colors. ✻ ✻

No. 3.
ORANGE YELLOW.

Useful in decorative work and interiors. Diluted it makes an excellent flesh tint and cannot be excelled in sunset effects.

Use direct from leaflet to get a strong, brilliant effect.

Remove clipping after film is dissolved.

Manufactured only by Japanese Water-Color Co., New York, U.S.A.

頂上好色頭

✱ ✱ Japanese Transparent Water-Colors. ✱ ✱

No. 4.
FLESH TINT.

These colors being very concentrated are of great strength, so care must be used in diluting them. In tinting the flesh the tendency to get the wash too strong. Be very careful with this color; try it on white paper before applying to pictures, and go over several times with a weak wash, rather than attempt shade first time; this is **Very Important.**

Flesh Tint diluted gives a rich shade of copper, nasturtium, and salmon.

Use direct from leaflet to get a strong, brilliant effect.
Remove clipping after film is dissolved.
Manufactured only by Japanese Water-Color Co., New York, U.S.A.

頂上好色・頭

✳ ✳ **Japanese Transparent Water-Colors.** ✳ ✳

No. 5.
GERANIUM PINK.

頂上好色頭

A very useful color for flower work, and one of the most brilliant of all reds. In figure pieces, where a bright effect is wanted it is particularly valuable. In its diluted gradations it is a beautiful pink, producing carnation pink, rose pink, apple blossom pink and rose madder for delicate flesh tints.

Use direct from leaflet to get a strong, brilliant effect.
Remove clipping after film is dissolved
Manufactured only by Japanese Water-Color Co., New York, U.S.A.

✳ ✳ Japanese Transparent Water-Colors. ✳ ✳

No. 6.
JAPONICA SCARLET.

A very useful color for interiors, garments, &c., and valuable in flower work. In its diluted shades it produces strawberry red, light red, madder red, and with **Deep Yellow** a rich shade of vermilion, blended with **Mahogany** a red brown, with **Sepia**, a venetian red.

Use direct from leaflet to get a strong, brilliant effect.
Remove clipping after film is dissolved.
Manufactured only by Japanese Water-Color Co., New York, U.S.A.

頂上好色頭

✻ ✻ Japanese Transparent Water-Colors. ✻ ✻

No. 7.
ROYAL CRIMSON.

This color is very useful in flower tinting, coloring of maps and charts, for interior work and figure pieces. With **Geranium Pink** it produces a rich carmine, with **Sky Blue** a warm purple, and in diluted form cardinal, claret, and like shades. This color very nearly approaches the Royal Purple of old, and is even now the acknowledged insignia of royalty.

Use direct from leaflet to get a strong, brilliant effect.
Remove clipping after film is dissolved.
Manufactured only by Japanese Water-Color Co., New York, U.S.A.

頂上好色頭

✳ ✳ **Japanese Transparent Water-Colors.** ✳ ✳

No. 8.
MAHOGANY BROWN.

Valuable in landscape and interior work. With **Japonica Scarlet** produces a terra cotta brown, with **Royal Crimson** a madder brown, and in diluted form, cinnamon, chestnut, sorrel and similar shades of brown. Use great care in applying this color, as it does not work so free as the other tints.

Use direct from leaflet to get a strong, brilliant effect.

Remove clipping after film is dissolved.

Manufactured only by Japanese Water-Color Co., New York, U.S.A.

✻ ✻ **Japanese Transparent Water-Colors.** ✻ ✻

No. 13.
DARK BLUE.

頂上好色頭

Somewhat deeper and warmer than **Sky Blue**—valuable in flower work and in combination with other tints produces a variety of shades; washes well. Very strong, so use only small clipping.

Use direct from leaflet to get a strong, brilliant effect.
Remove clipping after film is dissolved.
Manufactured only by Japanese Water-Color Co., New York, U.S.A.

No. 15.
PEARL GRAY.

In its diluted form this is a beautiful gray, while if used at full strength it almost approaches a black. Useful in landscape work, for fences, rocks, old buildings, &c. Diluted it gives besides pearl gray, silver gray, stone and drab.

Use direct from leaflet to get a strong, brilliant effect.
Remove clipping after film is dissolved.
Manufactured only by Japanese Water-Color Co., New York, U.S.A.

Printed in the USA
CPSIA information can be obtained
at www.ICGtesting.com
LVHW022149291024
795186LV00030B/673

9 781015 033313